Modern Artists Albers

Harry N. Abrams, Inc., Publishers, New York

Werner Spies

Albers

Series Editor: Werner Spies

Translated from the German by Herma Plummer
Standard Book Number: 8109-4400-6
Library of Congress Catalogue Card Number: 75-125777

"In science one plus one is always two, in art it can also be three, or more."
(Josef Albers)

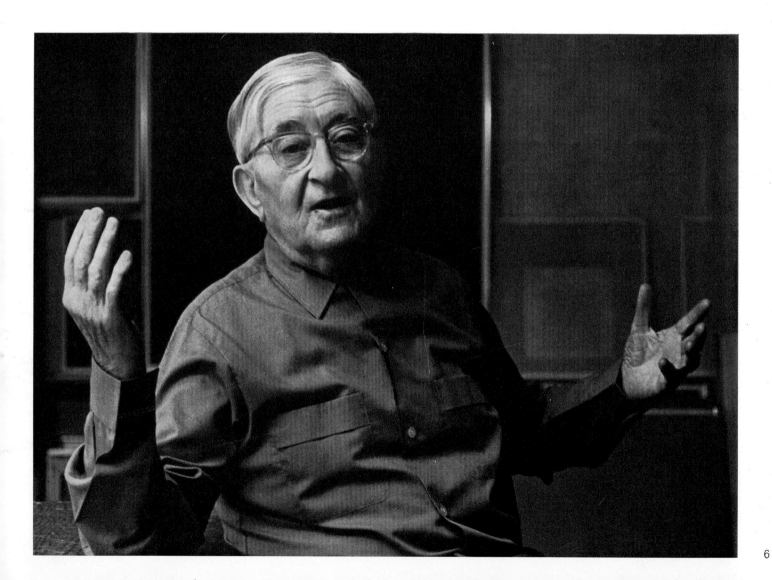

The world-wide breakthrough of Josef Albers as an artist occurred in the 1960s. Before that, Albers, who had been born in Bottrop in Westphalia in 1888, was considered primarily a pedagogue who in his creative work cultivated a kind of constructivist, concrete art.

His success as a teacher in the United States, after the dissolution of the Bauhaus, was so great that interest in the artist Albers receded. Among the great masters of his generation Albers is a latecomer. Until the exhibition "The Responsive Eye", which William C. Seitz arranged at the Museum of Modern Art in New York in 1965, he remained almost unknown.[1] This exhibition made him an outstanding representative of Optical Art. Suddenly one recognized in Albers one of the central figures of the contemporary avant garde

A critical examination of his work

His art seems intelligible at first glance. Nothing seems more understandable than the elements prevalent in his work: geometric line compositions on the one hand, simple color surfaces or spots or panels *(Farbflächen)* put next to each other, in contrast. His pictures and drawings offer themselves as a superb example of an art which can be divided into its parts. The material and the handwriting disappear completely behind the work. They have no voice in it. A superficial look permits one only to discover attributes of a skilful arrangement of optic-geometric facts. In this statement—the supposition that Albers' work confines itself to the visualization of visual facts—there is for many already an inherent judgment. For some it is a negative one: a work without secrets, without excitement. For others it will be a positive judgment: a work of the most advanced art ideology, i. e. an art which is repeatable and which circumvents the subjectivity of the artist.

Both judgments are the result of a superficial, first look, both simplify the "seeing" in a manner which would horrify this brilliant challenger of the eye. The training and the teaching of Albers pointed already in the direction of the theory that there is no formalistic association with lines and colors hidden in his work. His intellectual background proves this sufficiently. And an analysis of his work provides a finely shaded understanding. It is a work which requires us to interpret what our eyes have experi-

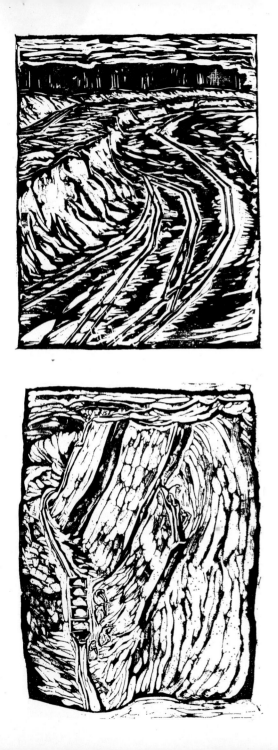

enced. There is only one system in this slowly developing, gradually progressing *oeuvre:* it is to collect facts of seeing which provoke the seeing, facts which already at the initial stage of perception are strong enough to captivate the viewer. In an impressive manner Albers makes us unsure of what we see. Not enough that he submits to us picture puzzles—he insists that we develop our "seeing" experiences into experiences of our own self. The demonstrations which he gives us—demonstrations of our faulty seeing, our bad seeing and our incapability to see definitively—are supposed to produce an intellectual psychic effect. The irritation of the retina is supposed to be converted—it is supposed to irritate us.

There are works of Albers—as for instance the *Structural Constellations* (36–39) which challenge not only our seeing, but also our understanding and our interpretation of what we have perceived. We alternate between perception of level surfaces and perception of space. Our seeing and our understanding alternate consistently. We cannot stabilize the picture. Albers achieves this effect with simple means. Actually, within the course of a development over decades he has systematically tried, as much as possible, to restrict the formal material used in his pictures and drawings. The last stage of his work, the *Homage to the Square* (50–57) is based on perfectly simple picture models.

The Problem of Expressionism

Albers' work—a union of creative formation and continuous contact with an environment willing to learn and ready for exchange—has developed slowly, almost in slow motion. There is no variety in this work. Everything is aimed at a deepening of the problems posed. The methods which Albers uses, and those which he rejects, are proof of this. Variety, seriation are the correlation of a slow development. His training and his early work show that even as a young man Albers went his own way. He belongs to a generation which in Germany vacillated between self-related expressionism and wide open, critical dadaism. His earliest works relate to expressionism but quickly change it into a more formal preoccupation with expressionist themes. It is feasible that this expressive tendency of the times was softened by the *milieu* which Albers had chosen.

At first he was an elementary school teacher, just as Mondrian was. He had social relations with people who did not permit him complete retreat into an individual, expressive stand. He always knew how to state definitively his convictions and perceptions. The short report which he wrote in 1959 for the *Dülmener Heimatblätter* appears therefore as an expression of this early attachment to an activity closely related to society. Albers claims that this is the basis of the method of his teaching at the Bauhaus, at Black Mountain College and at Yale, as well as during his year at the agricultural school at Weddern near Dülmen (1909—10). He says that "this became important especially for my art courses in workshop and studio classes for which I . . . had made it a point to find a new 'step by step' learning method".[2]

The pedagogic Point of Departure

Albers did not plan his work as a subjective, freely creating artist, but as a man who, up to his old age, is trying to supply the basis for the aesthetic reception of his work as a new art which rests on perceptual problems. Based on his continuous contact with students, he came to the realization that there is no absolute absorptive capability, and that the teaching of art appreciation, as well as training in artistic work, has to be geared to the students' respective stage of development. His teaching and his work are not, in the last analysis, subject to an intellectual fixation. Instead of an unequivocal meaning we continuously see a subjective approach. The ambiguity which Albers points out reflects the ambiguity of human existence. His concept of art is therefore not at all formalistic. Albers is in agreement with life in general: "Art is the sphere which reflects all questions of life—not only formal problems such as proportion and equilibrium, but also particularly the intellectual and psychic aspects of philosophy and religion, as well as of sociology or the economy. And therefore art is an important, inestimable educational factor."[3]

The first works of Albers which we know—selfportraits, views of cities, representations of sandpits and work houses (mostly linocuts and lithographs)—show the influence of the graphic art of Munch and of the painters of the *Brücke* group (7–10). All of these were done during the First World War. Albers was an elementary school teacher in his birthplace Bottrop at the time. In 1913 he interrupted this career for the first time, for a period of two years, in order to attend the Royal Art School in Berlin. There he was trained to be an art teacher at secondary schools. In spite of this he returned to his job as an elementary school teacher in Bottrop, while at the same time taking courses at the School of Applied Arts in Essen.

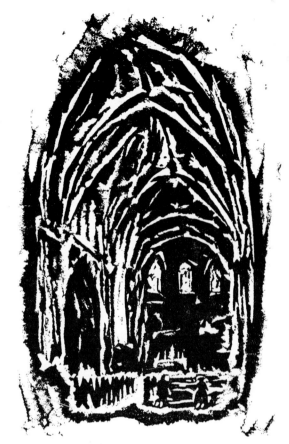

The Early Works

The closeness to expressionism is most evident in Albers' first self-portraits. The expression remains repressed—instead of a strong psychic movement the face shows a critical glance from a secure, introverted sphere. A quizzical scepticism is evident. Although these self-portraits use the expressionistic manner, they show a conscious reserve toward the expressive. Albers always considered abstraction more important than expression.

In a conversation with Katherine Kuh in 1934 he said: "And I very much distrust expression as a driving force as well as an aim in art."[4] The contrasting black and white pattern of the linocuts and lithographs of the early period implies the influence of expressionism. The style of the works points to an argumentation or struggle with Cubism. In some of them one can see Albers' intention to schematically construct a picture out of parts of form. The theme almost completely disappears behind the confusion of strong lines of white and black strokes. In the *Sandpit* pictures especially (8), in which the view from a high point leaves only a small line of horizon,

the illustration is part realism and part free graphism. The mixture of lines, paths and tracks is moulded into a scaffolding. In the interior view of a Gothic church (9), which reminds one of Delaunay's *Saint Séverin* views, Albers finally takes such a scaffolding as his principal theme.

Seeing in Situations—The Variation

The contents of these works, which are based on geometric, yet free drawing, seem to have played practically no role in the further development of the artist. However, something else already seems to appear in this early phase: the variation of a theme. This principle Albers never abandoned, beginning in the 'thirties. There is no longer a definitive picture solution—one picture exists only in its relation to another. Albers creates series and forces us to relate the individual picture and the context in which it appears. He demands that we *see* in situations. The interdependence of these works is a part of their meaning. Cycles of variation in such a distinctive manner were noted first in the work of Monet. Monet painted haystacks, poplars, water lilies and the Cathedral of Rouen in different versions which were closely connected and with slowly varying illumination. He determined stages of seeing which came about 10

through changing light and changing point of view. This is how the first sequences of pictures originated which had the visual ambiguity of an object as their theme. Monet achieved this effect through color. In Albers' early work color barely plays a role. In his cycles there is a variation of sketched structures which concentrate on an object—sandpits, workers' house, etc. This early thinking in cycles is later split into two work groups: the graphic and the pictorial.

We will refer to this again later. Now it should only be said that the parallel to Monet is true only in the sense that we note a decisive point of departure for the study of optical problems in the sphere of art.[5] In Monet's work the seeing, the multilateral seeing of an object, becomes more important than the object itself. Yet the individual pictures which Monet presents are complete pictures; they fix visual experiences which are meant to be absolute. Albers is different. He not only relates a composition of lines or a picture composed of colors within a certain series, but he relates them even further because they demonstrate, individually considered, a fluctuating, continuously skipping "seeing picture", and because they escape any fixation at the stage of the individual picture.

As we look at Albers' work today we must conclude that this early tendency to take subjects without any differentiated thematic issue and to denigrate the substantive assertion further by variation, is an essential part of the artist.

Joining the Bauhaus

Until the spring of 1920, when Albers entered the newly founded Weimar Bauhaus as a student, he continued in search of further education and stimulation. Just before this, he had spent a year and a half in the painting class of Franz Stuck in Munich. He was already 32 years old when he decided to risk all his previous training. It was the concept of what he expected as a result of his decision (he was the oldest student at the Bauhaus) which led to the conflict with his teachers, a conflict in which Albers turned out to be right and which would prove to be of basic significance to him and to the Bauhaus.

Albers was attracted by the program of Gropius which aimed at the reunion of art and crafts.[6] After the first six-months term with Itten he was supposed to enter the class for wall painting while he himself preferred to get into the glass workshop. He disregarded his assignment and occupied himself with working with glass. He took a knapsack and hammer and collected fragments of bottles and glass in rubbish dumps. During this term Gropius reminded him of his obligation to devote himself exclusively to the study of wall painting since otherwise he would have to leave the Bauhaus. At the end of the second six-months term there was an exhibition at which Albers showed various studies in glass: "I thought that this would be my swan song at the Bauhaus."

But instead he received a letter from the Council of Masters, in which he was admitted to further study and even asked to reorganize the glass workshop of the Bauhaus.

Paul Klee encouraged him to send his glass works to the Secession Exhibition in Munich. However, they were not accepted since they were not paintings.

Glass Pictures—The Problem of the Material

With these works, Albers had severed his relationship with the world of objective painting. Besides a new and formalistic occupation with the pieces of glass he had found, there is for the first time the inner debate with the material which was to become so typical of his later teaching activity. The works created by his students under his guidance in the preliminary course are distinguished by an exceedingly imaginative handling of the material. Albers characterized his own first "fragment pictures" as "unprofessional" or "uncraftsmanlike". Actually he did treat glass in a new way. Instead of making a transparent wall out of broken glass, he mounted such pieces on various bases, such as tin, wall screens and lattices.[7] "Uncraftsmanlike" was supposed to mean an unorthodox treatment of the material involved. The first works which we know tend toward the concept of a painting. Their free compositions have a lyrical tension which is similar to the works of Kandinsky of the same period.

The glass pieces are inserted as amorphic color panes. The uneven circumferences of the glass fragments do not permit a regular, geometric composition. Above and beyond the lyrical impression, considerations of tactile matter play a role. Whenever a transparently mounted work made of different glass fragments was considerably de-materialized through the inroads of light, the different quality and varying thickness of the fragments became the most important theme of our seeing in these glass mountings on an opaque base. In these works we meet for the first time the problem of the "insecure seeing" which was so typical of Albers. The eye is confronted by an object which cannot be absorbed by the homogeneous seeing process. Apart from the content of the picture—lyrical tension which is inherent in the confrontation of these glass color shades—the juxtaposition of different kinds of glass with their different material effects seem to be the function of the picture (13).

The preoccupation with new materials and their unorthodox use is not new in the art of our century. Klimt, Picasso, the futurists, Dada, Max Ernst and Schwitters present numerous possibilities of how to harmonize different materials. The charm which distinguishes their works is palpable in both an optical and a tactile manner. Albers varies these solutions in his glass assemblages—the tactile attraction which is created by the synchronic juxtaposition of different materials disappears, in favor of a contrasting use of a single material.

The main contribution of Albers, the pedagogue, to the history of modern art—which is also a history of new free forms as well as materials used in an unorthodox manner—is the fact that he depersonalized a working material to the extreme. (The preliminary course at the Bauhaus gives ample evidence of this.) The aim of all these attempts is a conscious confusion of the eye, an analysis of fact and effect. "In dealing with color

14

15

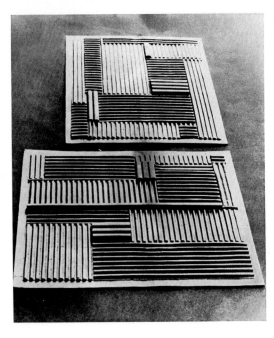

relativity or color illusion, it is practical to distinguish factual facts from actual facts."[8]
The glass collages are followed by the second series of glass works which are determined by a yet stronger geometrization. A part of this is the window in the Sommerfeld House which was built and furnished by the Bauhaus in Berlin-Dahlem. Albers reverts here to the traditional technique of stained glass: each color is separated from the other by a lead circumference. The new element here is the strong and geometric infusion of rhythm into the picture in which larger and smaller, stereometrically clear and more complicated surfaces confront each other. The glass windows which Albers did later in the Weimar Bauhaus, in the Ullstein House in Berlin-Tempelhof and in the Grassi Museum in Leipzig, confine themselves to only a few colors—white, light red and light yellow.

The decisive innovation is noted in the wall or one-pane pictures. They in turn point to the glass collages, not in their execution and construction, but in the use of glass as an opaque material (14–15). White milk glass panes are the carriers of the pictures. A black or colored coating is put over these panes. Albers then pastes paper stencils over the pane which has two layers of color. The cut-out parts are treated with a sand-blaster which removes the colored coating and uncovers the white core layer. The charm of these glass pictures is the change from black, red or blue panes to a lower layer which is white, uncovered by the sand gravure. At one point the colored coating is dominant, then again it is the uncovered white milk glass. In some of the wall glass pictures Albers introduces dull intermediate shades. The black coating is brightened through a gentle blowing with the sand-blaster.

The Transition to a Geometric Style

The first works which are based on a geometric order are limited to a flat construction. There are no perspective-space effects. Albers seems to revert to the exercise slate of Ludwig Hirschfeld-Mack, who undertook systematic color-physiological investigations at the Bauhaus. Albers liked to use the arithmetic progression of colored and white strips in order to further rhythm. He thereby achieved clear proportions and measures which satisfied the intellect.[9] It is this same satisfaction which we experience with the architectural plans and furniture designs of the Bauhaus. The distribution of the masses, the change between full and empty strips connect the "wall glass pictures" with this architecture. Albers actually gives some of his work architectural titles, such as *Skyscrapers* (Hochbauten) (14).[10] The systematization of building which was achieved at the Bauhaus by Gropius, Muche and Breuer leads to the systematization of the picture by Albers.

The transition from the free to the geometric style falls into the period during which the Bauhaus itself turned from the handicraft-Romantic to the engineer-constructivist. It may be assumed that Theo van Doesburg, who gave a course in style in Weimar from March to July 1922 which was attended by certain students and teachers of the Bauhaus, had a decisive influence.[11]

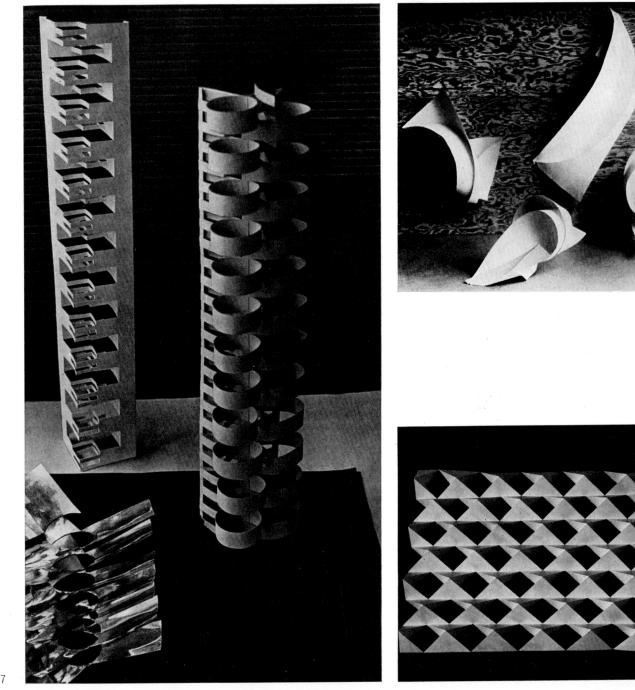

In 1923 Albers, the Bauhaus student, became Albers, the teacher, who initially let his students do studies in materials (1923—25), then took over the preliminary course for the first term (1925—28), and from 1928 on was in charge of the complete elementary course.[12] From 1923 to 1933, when the Nazis closed the Bauhaus (which in the meantime had moved to Berlin), Albers was prominently responsible for the experimental spirit. No one else was at the Bauhaus for so long a period as he, no one ever conducted a more comprehensive, systematic preliminary course than he. His teaching was probably the most universal—it was not, like that of Itten, geared only to the creative individual, and was also not directed principally toward the constructivist, like, for instance, that of Moholy-Nagy. Both Itten and Moholy-Nagy had as their ideal the individual achievement, the individual artistry. Albers' teaching encompassed a much wider sphere—a comprehensive visual training. The works done by the students of Albers' preliminary course which are still available show that he did not want them to think and compose primarily in a formal manner but that the important thing was the intensive use and study of a given working material (16–17).

In 1928, on the occasion of the International Congress for Art Education, Albers gave a lecture in Prague which was in effect a report on the teaching at the Bauhaus. This lecture was the basis of the much more basic article "Werklicher Formunterricht" (Education in Application of Form) which appeared in the publication *Bauhaus* in 1928 (No. 2/3). The primary consideration is the handling of the work material. "Building" was more important to Albers than painting. Only later, after his move to the United States, did Albers include color in his pedagogy. This article, which is illustrated with several, now quite well known works originating in Albers' preliminary course (*Plastic Material Study*, *Positive-Negative Foldings*, *Surface Plastic Study—Flächig-plastische Fakturstudie*) resumes—after an interval of nine years—the basic theory of the manifesto which Gropius had published, in conjunction with the program of the Bauhaus. Gropius said: "This world of artists and craftsmen who only draw and paint, must again become a world which *builds*." The salvation is craftsmanship. Art must be reborn from craftsmanship. The program of the Bauhaus concludes: "Architects, painters and sculptors are craftsmen in the true sense of the word. Therefore the indispensable basis for all artistic creativity must be the thorough training in the handicrafts of all students in workships as well as in training studios."

Political and Sociological Points of View

Albers also emphasizes the importance of craftsmanship, but this receives a new definition based on experiences gained during many years of work at the Bauhaus. The point is no longer just to synthesize art and craftsmanship. The thorough understanding of craftsmanship alone and a solid, yet uncreative dexterity are not sufficient. Albers wants to broaden the realm of handicraft in a creative expansion of the

pragmatic handling of work material which used to be determined by technical considerations. The premise is the fact that we live in an "economically oriented period". The handling of the working material must be a creative one: "In technical science its productive treatment has often been determined by long *tradition*. Therefore technical training often consists of a continuation and acceptance of accepted work methods." Albers concludes: "This kind of training kills creativity, and restrains invention." Instead of the professional use of materials, executed with professional tools, Albers propagates: "In the beginning there is *only* the material, and if at all possible without tools. These are obviously very individual considerations, and individual methods." Added to unorthodox procedures which create new techniques and new possibilities of expression ("many important discoveries originate with *non*-professionals—innovations are usually rejected by professionals—pioneers are usually not professionals, or even start out as non-professionals") is a preference for materials which are not ordinarily used in the sphere of technology and of handicrafts: "Building with corrugated cardboard, wire mesh, cellophane and transparit, labels, newspapers and wall paper, straw, rubber, match boxes, confetti and paper ribbons, gramophone needles and razor blades."

The use of the materials is supposed to be rational. "Each material is used *without any waste*, if at all possible, and without any loss in its full exploitability." This economy serves one purpose: to create structures which have new forms. Material and space, which govern the composition, have an inner relationship. The material speaks similarly to that which in the contemporary architecture of the Bauhaus has the effect of a skeleton, or where it fulfills a static function. The filling (in architecture, for example, glass) is here replaced by space, by the negative which intrudes as a creative element. The material is also emphasized by what Albers calls the "negative elements" (empty spaces and dimensional relationships). There are not only formal points of view behind his considerations, but also sociological ones, which Albers formulates thus: "An equal consideration and evaluation of positive and negative elements would result in no *differentiation*. In essence we no longer differentiate between carry and being carried, we do not recognize a difference between serve and being served, decorate and being decorated. Each element or structural component has to be effective helping and being helped, supporting and being supported. In this way the pedestal and the frame disappear, and with it the monument which on an excess of foundation carries an excess of super-structure."

At this point color plays practically no role in the teaching of Albers. One can differentiate roughly between two periods: the period of the Bauhaus, whose main emphasis was materials, and that in the United States (Black Mountain College, Yale University) which placed the preoccupation with color alongside the concern with materials. In Weimar and Dessau, Albers used materials analogously with color. He clearly explained this relationship—As color *forms* a relationship to color (Sound interval—tension, Harmony—discord), so surface forms with dactylic (with the finger tips) and optical qualifications do become related. Just as Red and Green complement each other, i. e. are contrast and compensation, so bricks and sackcloth, glass and stearin, window screens and wool, etc. can "relate" to each other.

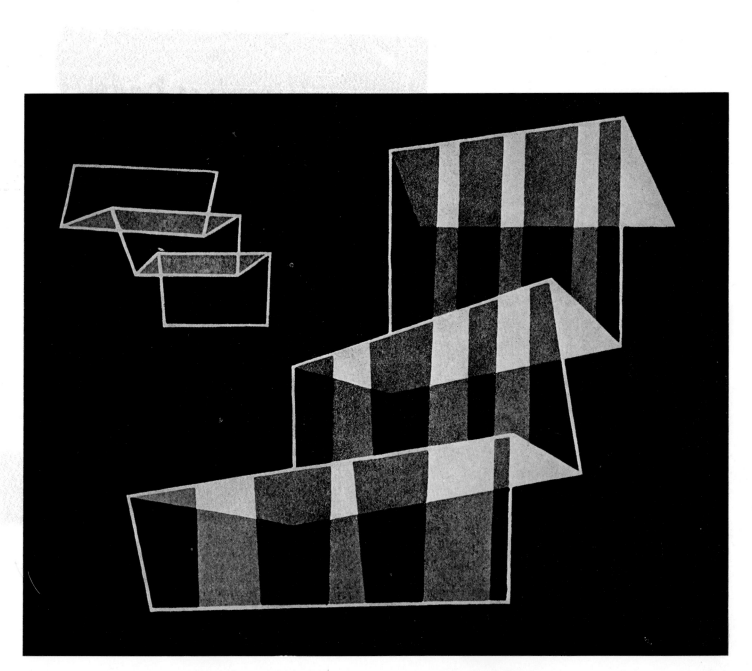

22

24

Preoccupation with Perceptual Problems

The problems and methods of work which Albers has exhaustively studied in connection with materials, are only of indirect benefit to him. The works which he executed during his Bauhaus period go their own way. The preoccupation with materials is only slightly in evidence. Albers demonstrates spatial problems with two-dimensional means. Some of the works originate with plastic studies made on grooved paper which had been developed in the preliminary course. The preoccupation with such architectural structures runs parallel to the study of perceptual problems, with optical illusions which are palpable in the realm of geometrically simple structures.

The innovation is to be found in the fact that Albers forces the architectural-constructivist compositions in his drawings and paintings to a thematic philosophy which has nothing in common with the geometric world of the constructivists. Van Doesburg as well as Moholy-Nagy, who at the time also created pictures based on geometric forms, used their pictorial elements for illustrations which were meant to be concrete: color and form represent just themselves. The picture no longer contains any symbolism, any reference to a reality outside the picture.

Ambivalent Forms

Not Albers. Although at first glance he also seems to restrict himself to the facts which the picture is supposed to transmit, there are in his works effects which are beyond the reality of the picture. In this sense his painting—like that of Malevich and Mondrian—remains the bearer of a spiritual message outside the strict spirit of painting. Malevich and Mondrian wanted to paint pictures which contained metaphysical conceptions. Albers on the other hand thematizes questions which engage our "looking into" and our "understanding". He attempts to present ambivalent forms which demand from us different decisions. When we look at the famous staircase form (21) we vacillate between various interpretations. What seems to be in the background steps forward, what seems to descend, actually ascends. We do not see a definitive illustration—we have to argue between different interpretations. No single one seems to be more important than the other. The degree of uncertainty is insured to such an extent that the various possibilities of understanding balance each other. This does not only apply to the demonstration of different interpretations. If this were the case, then the picture would be nothing else but a species of variations painted one on top of the other. Albers provokes in the spectator an uncertainty by superimposing contrary interpretations which are mutually exclusive. The spectator remains uncertain—he is incapable of deciding in favor of one interpretation or the other. He may momentarily prefer one and may make an effort to concentrate on it. But as soon as this concentration diminishes, the picture offers him further, indecisive structures. This vacillating attempt to read the picture, the uncertainty and turbulence of perception—that is the actual content of the illustration.

28

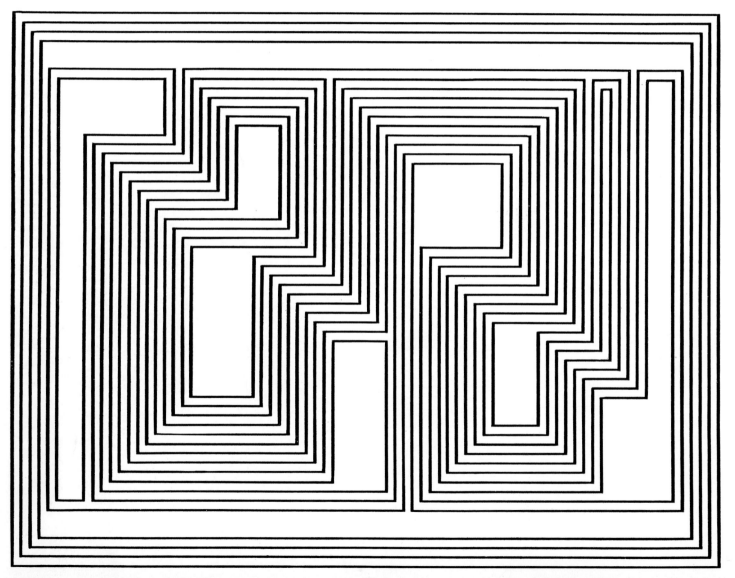

30

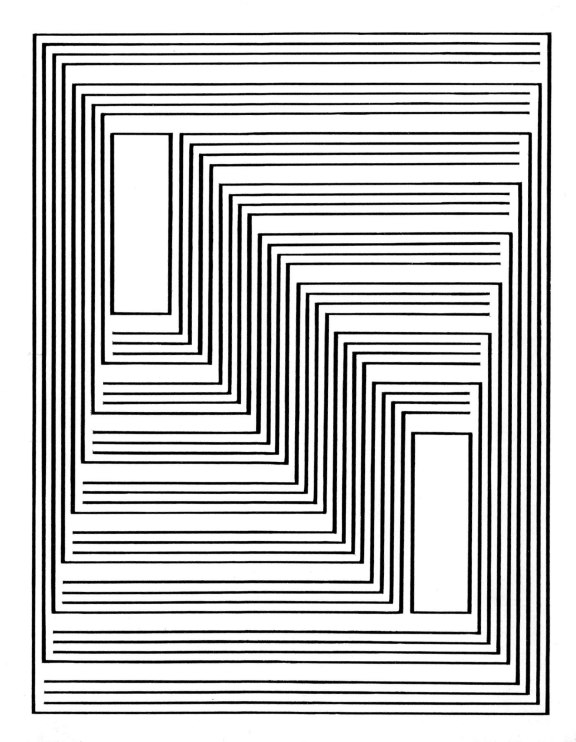

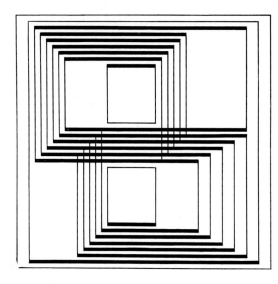

The complicated method of "seeing" and "perceiving" which Albers demonstrates from the very beginning in his serial compositions, becomes even more forceful in such works. While the early variations are geared to the ability of a sensitive, trained eye to differentiate, these pictures which cannot be categorized attempt for the first time to seriously question the sensitive act of "seeing".

Albers approached these problems only briefly before he went to the United States in 1933. Only in the United States were they to find their impressive solutions. The work of the last thirty years—that of the painter as well as that of the draftsman—revolves around the visualization of our perceptual insecurity. In order to demonstrate this, Albers constructs an impressive, logical mental structure: a logic whose aim it is to prove the lack of logic in our perception.

Albers in the United States

Only in his later work do these ideas come to full fruition. For the time being there is a series of works in which geometric and lyric-atmospheric elements clash with each other. These include principally the graphic folios of this period, his free studies. In his woodcuts, the texture of the wood is an important element. Indeed, he concentrates consciously on the texture. He uses pieces of Polish pine for printing plates in order to gain a parallel pattern of grain. With a paper knife he depresses the soft fibres; the hard fibres are used for the geometric patterns in this high pressure technique (26–27). There is a further graphic suite (cold needle etchings, 28–29) done in 1942, and more woodcuts (1944–48, 33), which also belong to those works in which Albers wanted to operate unhampered, with automatic means, or in which he contrasted the geometry of the drawing with geometric (or geometrizing) structures of wood. From this period of transition we also have a series of pictures in which Albers tried to meld the geometric pattern of lines with an orthodox (pictorial) kind of background. There are some examples which dispense with the geometric constant. They introduce tachistic elements.

Albers' importance manifests itself principally in those works in which he achieves a relative, alternating psychic effect by virtue of apparently completely absolute means (geometric lineation; a consistent color tone applied without facture). In the United States, Albers concentrated almost exclusively on a kind of drawing and painting which remains independent of factural values. The transition is accomplished by a series, conceived in Berlin, consisting of almost a hundred variations of an isomorphic shape—a violin peg (24–25). Albers proceeds from a motive which remains strictly codified. It only *appears* to be a free form involving irregular curves. The G-peg is taken from reality as an existing form. He analyzes the latter, breaks it up into proportions. Each one of these form proportions can be filled with different colors—black, white and two shades of grey. Albers builds his first consistent serial cycle on the permutability of colors, the variation of color and tone relationships. Albers was to retain this working method, increasingly simplifying the initial form chosen for variation.

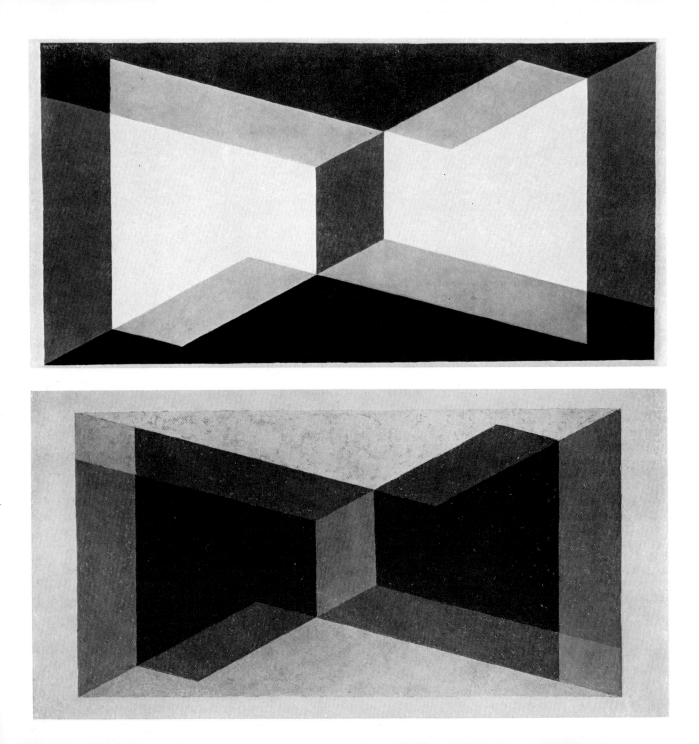

34

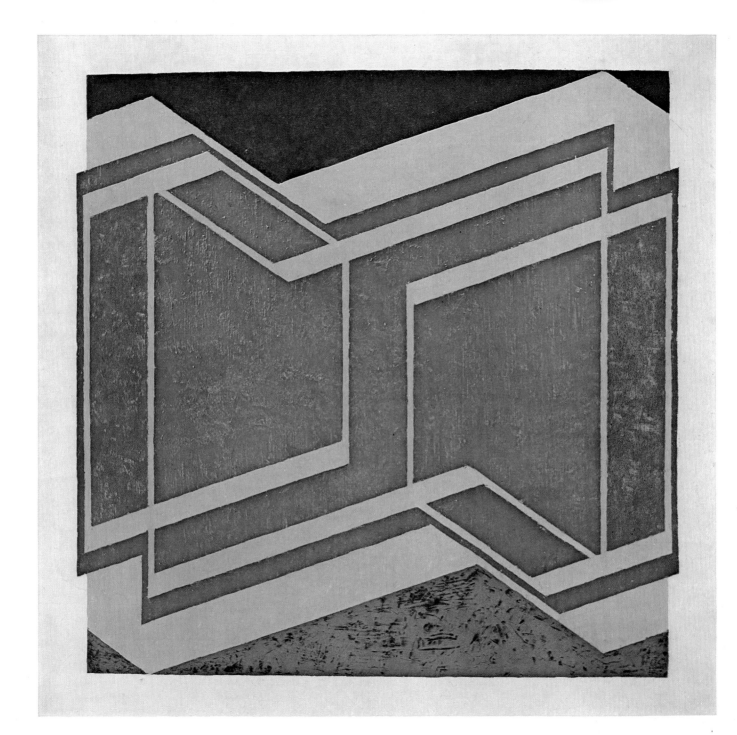

The choice of the violin key still had a symbolic meaning. The reference to a tonal system, to color scales and tonal scales was apparent. Albers also adduced the parallel to a musical system in the thesis called *Reihungen* (Sequences) which he had written at the Bauhaus.

At that time they were confined to working materials: "Keyboard scales from hard to soft, from smooth to rough, warm to cold, or angular to amorphous, polished to sticky-absorbent, optical scales of matter, as for example close versus wide-meshed, transparent versus translucent, clear versus muddy and solid." The series of G-pegs is more strongly dependent than any other series on a comparative "seeing". Considered by and in themselves these works appear tautological. Only when viewed next to each other do they transmit to the spectator a different aspect. But since the different aspects vary only in tiny details, the spectator must be prepared for a difficult comparison. This is Albers' intention. The juxtaposition of at least two variations of a theme becomes indispensable. Only the color series *Homage to the Square* (50–57) seems to make an exception. In this series there is the possibility of comparison between at least three colors, of which the intermediate one has a reciprocal relationship to the other two. In the double-centric pictures which originated between 1939 and 1949, Albers synthesizes the interdependence of two versions in one work.

Graphic Tectonic and Structural Constellations

Two groups of works—the zinc lithographs *Graphic Tectonic* (30–32) and the drawings and engravings *Structural Constellations* (36–39)—which include the *Transformations* done earlier—recall the *Steps* which had been developed at the beginning of the 'thirties. Albers confines himself to a linear drawing—only temporarily are there surface elements in the *Transformations* and *Structural Constellations*. There is only one modulation—the varyingly thick yet constant brush-strokes (two degrees of thickness in the *Transformations* and *Structural Constellations*, up to four in the *Graphic Tectonic*). The varying space between the black lines modulates the intensity of the white lines between them, as does the the emphasis of the black color. In the first group consisting of eight works, the *Graphic Tectonic*, there are only horizontal and vertical lines. These are usually very close to each other, forming a system of lines which at the crossing points results in a lattice. Each solution is quite distinct from the other.

All the works have one thing in common: the slope in perspective caused by the horizontal and vertical lines. Elements of perspective and space tug at those with no perspective. The works thus have a dynamic trait which the viewer wishes to pursue but which he cannot completely achieve. If he succeeds in following a line which is to be seen in perspective, to the background of the picture, he reaches a point at which the depth of the picture suddenly jumps into the foreground and with tremendous psychic force converts spatiality into a flat surface. He cannot see any of these structures distinctly.

There is an even more deliberate and successful confusion of the eye in the second group, the *Structural Constellations*.[13] The contrast between the brushstroke, and the wide surface circumscribed by strokes, differentiates this group from the first one which, on the whole, creates a more graphic effect. There are mostly double-centric forms in the *Structural Constellations*. Thus this series is the continuation of works like *The Impossible* (Die Unmöglichen), *Equal and Unequal* (1938), *Biconjugate* (1943), *Modified Repetition* (1943)—pictures which already indicate the motive of *Structural Constellations*. The pictorial execution, however, weakens the effect. A study of the *Structural Constellations* which were done later makes it easier for us to understand the theme of these pictures. Albers has developed the system of an alternating understanding of one form (one form appears interchangeably as background for the other, and vice versa) into an inextricable pattern of two- and three-dimensional meanings of the drawings.

The constellations which Albers presents here can no longer be understood, as was still the case with the staircase figure. Because the figure itself is incomprehensible it makes a fool of the spectator. A conflict arises between factual fact and actual fact. *Factual* are the line patterns in their ultra-simple, economical use, which consist of plain and logical pictorial material. *Actual*, challenging our understanding, is the "irrational penetration of forms" (Albers). Here there results an insoluble discrepancy between "seeing" and "perceiving", between perception and apperception.

Albers' main problem is that of "Aporie". This incompatibility is an experience which runs counter to our desire to establish a form. Within seconds, a solution is offered to the spectator—yet even while one is still looking, even before the solution can be comprehended, it has already been put in question. Our eye reacts to these patterns as a *perpetuum mobile*, it runs after a perception which again and again makes it dizzy. Albers has executed these drawings with a completely depersonalized technique (with a ruler), or has had them done on the basis of sketches. The optical stimuli are independent of any handwriting.

The more neutral the technique, the more strongly does the perceptive reflex function. Handwriting, facture, personal interpretation of technique—as individual ingredients—are opposed to this kind of art. Perfection is its prerequisite.

Geometric Surrealism

Albers' line drawings make the difference between him and the constructivist preoccupation of other artists very evident. He is not concerned with geometry. Albers is in search of forms which will pierce through the assurance of the geometric order. One could actually speak of a geometric surrealism. We run into deceptive structures which remind us of those of the Mannerists. In a certain sense these make one think of the anamorphosists of the seventeenth century. They were also ambiguous—the first impression of the picture was possibly different from a later perception. The geometric play with perspective creates pictures which continuously collapse. The

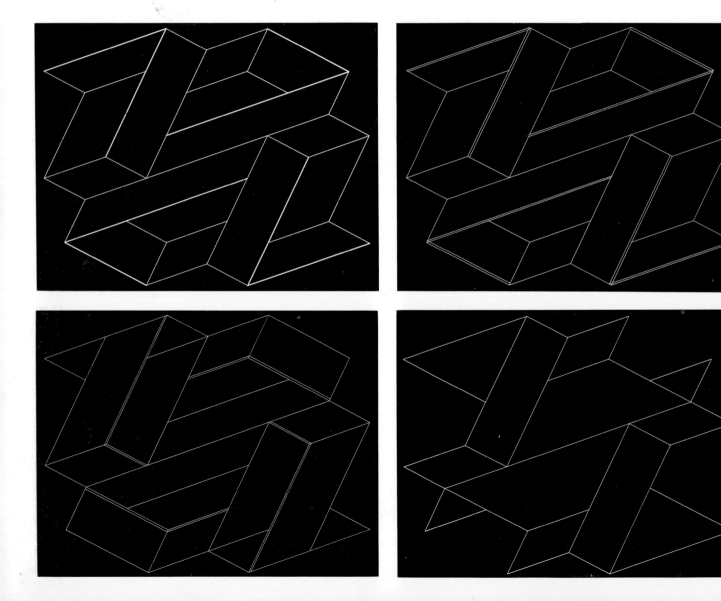

38

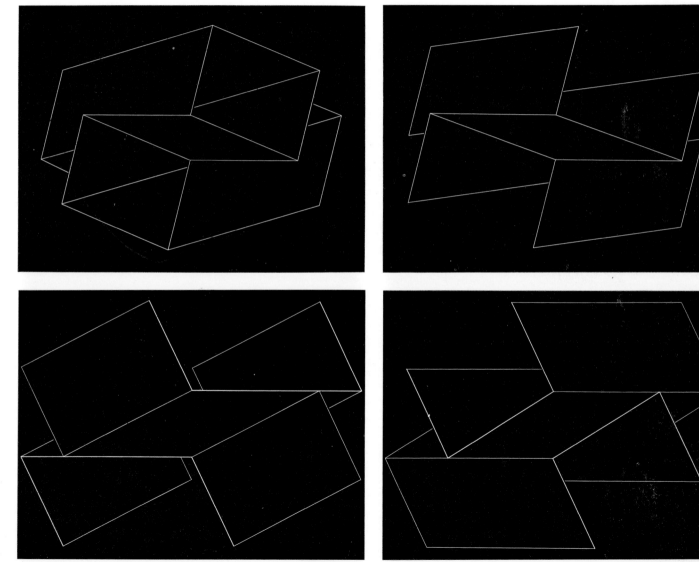

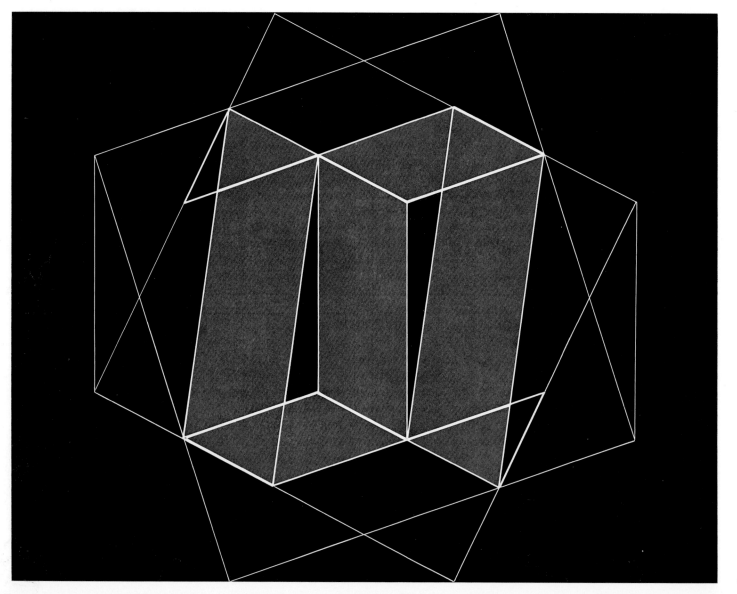

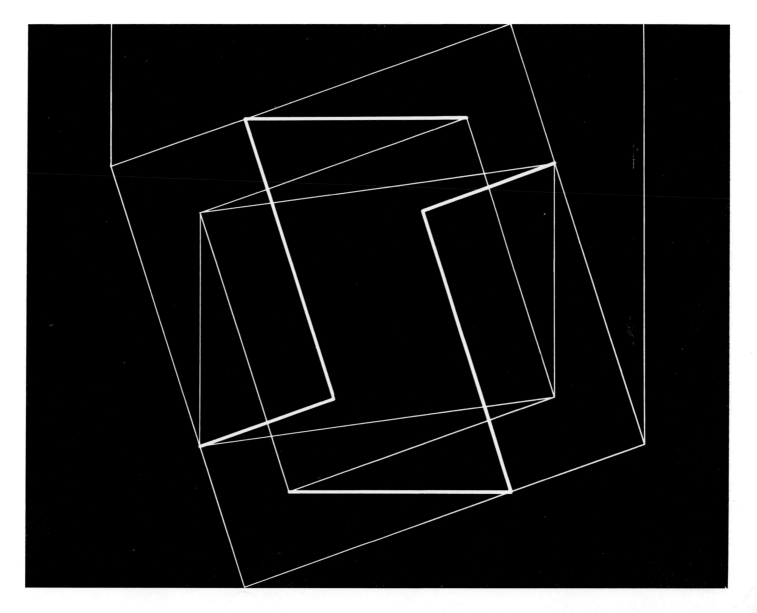

mechanism of optical illusion fits into a period which had as its aim a broadening of cognition and an inventory of those objects which explode the legitimacy of nature. We see an echo of this irrational geometry in the works of Klee, particularly in his labyrinthine geometrical picture *Limits of Reason* (Grenzen des Verstandes) (1927). In Albers' selection of form the knowledge of optical illusions, which were being discussed in connection with Gestalt theory, also plays a role. His staircase form relates to the reversible staircase of Schröder, and his no longer fixable *Structural Constellations* make reference to the Thiéry figure.

Color and Form—Interaction of Color

In *Biconjugate* and *Modified Repetition*, two themes are superimposed: that of the interaction of colors and that of linear constellations. It is in keeping with his constant demand for work economy (maximum effect with a minimum of means) that Albers was later to treat these two themes separately. Both work groups, those concerned with color formation, and those with line formation, have the same aim: to demonstrate the relativity of our seeing or visual perception.

Interaction of Color, the monumental textbook dedicated to his students, summarizes his theory of color. He wants to discipline our reaction to color. There is one distinctive difference between this book and all other books on the science of color: it contains more psychology of color, more visual training than actual color theory. The structure of the book is indicative of this. Only in the last part does Albers present the various important color systems. In the introduction he describes the experimental method: "In visual perception a color is almost never seen as that which it actually is, i. e. as that which it is physically. Thus color becomes the most relative medium of art. In order to use color successfully, one must recognize that color deceives constantly. Therefore we do not start with the study of color systems. One has to experience the fact that one and the same color permits innumerable variants . . . This book therefore does not accept the academic concept of theory and practice. Perhaps it proceeds inversely—places practice before theory which, as a matter of fact, is only the product of practice."

Physical Reality—Psychic Effect

The first exercises consist of having practical experiences with color illusions and thus realizing the instability of color. This relativity is caused by the conflict between physical reality and psychic effect. Albers used a trial and error method in order to explore the relative medium of color. For example, two different colors appear the same in a certain subject-matter, or one color looks like two; there are inverse backgrounds, intensity of color, after-images, colorfulness, simultaneous contrasts, 44

effects of apparent transparency, transparency and spatial illusions, color limits and plasticity—all these themes are illustrated in the students' studies. Here is an important result of these exercises: in the sphere of color deception there is no certain way of reducing the deception, no way of learning how to eliminate any further deception. Our eye reacts each time in a new and unprepared manner, as in the graphic cycles, in which, after frequent viewing, we still vacillate between surface and spatial imagination.

As a premise for Albers' own pictures the quantity exercises are important. Each color can, in a logically active sense, be brought together with another. This is not a question of taste but of properly determined quantities. Albers disregards his personal predilection for color harmonies. The latter, as he says, "are also subject to revision, just as prejudices against people are."

The Non-Border Line Between Colors

The question of the border line—or more correctly, the non-border line— between two colors becomes important in Albers' considerations. The manner in which the spatial effect of color is perceived, is dependent on that non-border line. "With increasing sensibility of the mixtures one will discover that distance, proximity and equidistance between colors can be established by means of the border line between mixed color and the original color." The mixed color, which lies between its two parental or primary colors, can have an intermediate placement. It then has equilibrium. Neither of the two parent or primary colors is dominant. If one of the two parent or primary colors does dominate, then the mixed color which is in between acts differently towards the parent colors. The softer border line points to proximity to a parent color, to a connection, while the harder points to distance, to separation. The "interaction", the penetration, is dependent on border lines between colors which are not too abrupt. Albers is not concerned with clear, spatial separation violently experienced. It is therefore quite normal for him to reject the problems of the hard-edge painters. Albers is trying to dematerialize the border line between two colors, two tones. Hard-edge establishes the border line; interaction of color cuts it down, creates a zone of inverse osmosis.

The determination of such tonal relationships usually has reference to the color series of Chevreul[15]. However, this gradation, which has been arrived at by a regular addition of color values, does not satisfy our visual needs: the constant augmentation does not result in a gradation which we perceive as systematic. Albers therefore reverts to the correction of the Chevreul law which Wilhelm Eduard Weber and Gustav Theodor Fechner had found. These two showed that physical-arithmetic progression, being too slow and too inactive, could not present us with a step by step progression. In arithmetic progression the rate of growth becomes ever smaller. The physically straight line has the psychological effect of being a curved line. The saturation point has been reached. Weber and Fechner discovered that in the sphere of color a psy-

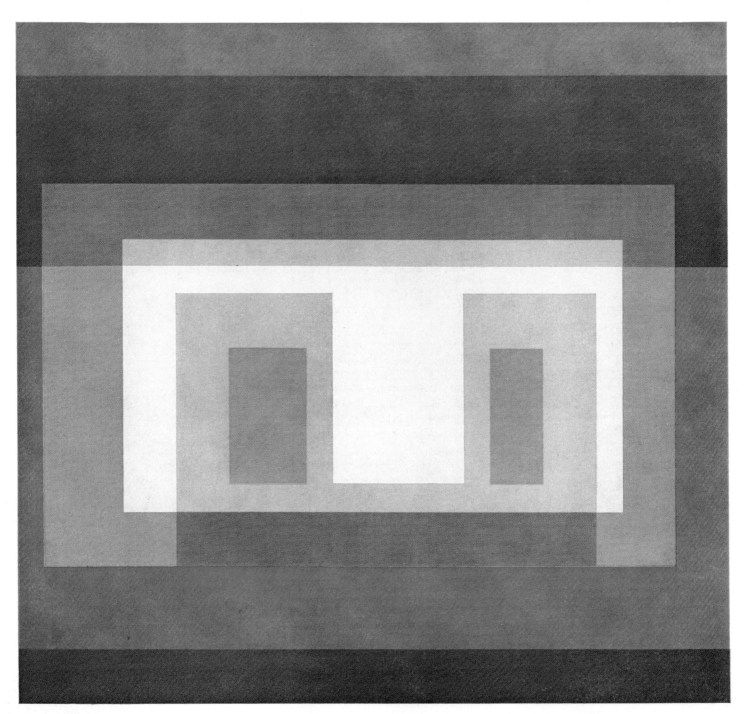

46

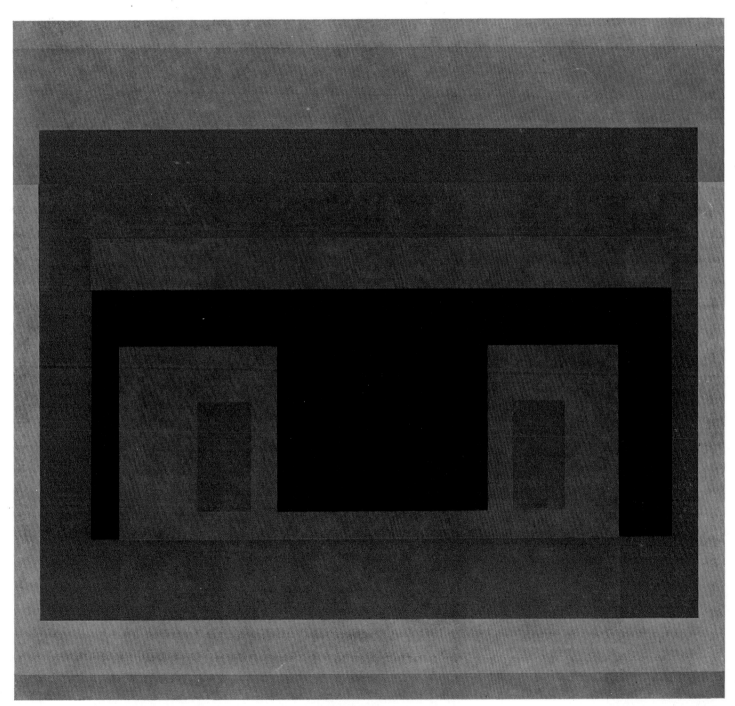

47

chological-arithmetic progression is achieved by a geometric progression of physical facts. The progression which we consider, therefore, follows the pattern 1, 2, 4, 8, 16.

Intellectualism and Pictorial Lyricism

Out of the multitude of observations and considerations which Albers mentions in *Interaction of Color*, special mention should be made of the discussion of the Bezold effect. In a multi-colored pattern an entirely different and contrary effect can be achieved by altering a single color. A small twist may change a color combination fundamentally. This discovery was used to good effect in Albers' *Homage to the Square* (50–57). The study of *Interaction of Color* as a comprehensive theory of color harmony should accompany the study of Albers' pictures.[16] This book shows the peculiarity of Albers' art: intellectualism which continuously borders on the limits of reason, and pictorial lyricism which somehow should be supervised intellectually.
Albers demonstrates this particularly well in the *Variations on a Theme* (46–47). They were developed from the double-centric works. Just as in the case of the violin pegs, there is here also a basic pattern which is filled out in different colors. Questions of apparent color penetration become important: one color seems to supersede another. Albers does not actually make these mixtures, he does not mix colors, he puts the colors on the picture right out of the tube. Such individual observations, however, remain subordinate to a total color image in the *Variations*.

Homage to the Square

Only with the *Homage to the Square* series (50–57) did Albers finally arrive at a brilliant way of demonstrating color phenomenona. Besides, the quadrangle is a form codified by Malevich, an intellectual form. The quadrangle expresses new thoughts. Albers transforms it into a physical-psychic reality full of suspense. He offers us hundreds of variations. He uses different schemata. He uses either three or four colors. The visual fusion of three or four quadrangles reminds us of graphic exercises *(Graphic Tectonic)* and of exercises which originated in the preliminary course at the Bauhaus. At one point the small middle form seems to step out of the picture, and then again it seems to withdraw into its very depth. This back-and-forth on which the plastic perception of these interlaced color zones is dependent, is modified by illumination. In clear daylight a blue zone remains dark and deeply hidden in the picture frame, while in the twilight (or waning light) the complete opposite is true: the red loses brightness, the blue assumes an increasingly powerful glow.
There is no particular reason for any of the different schemata (49); they serve only to solve various problems of quantity.[17] There are certain schemata which balance the participation of colors more strongly than others. They all have one thing in common:

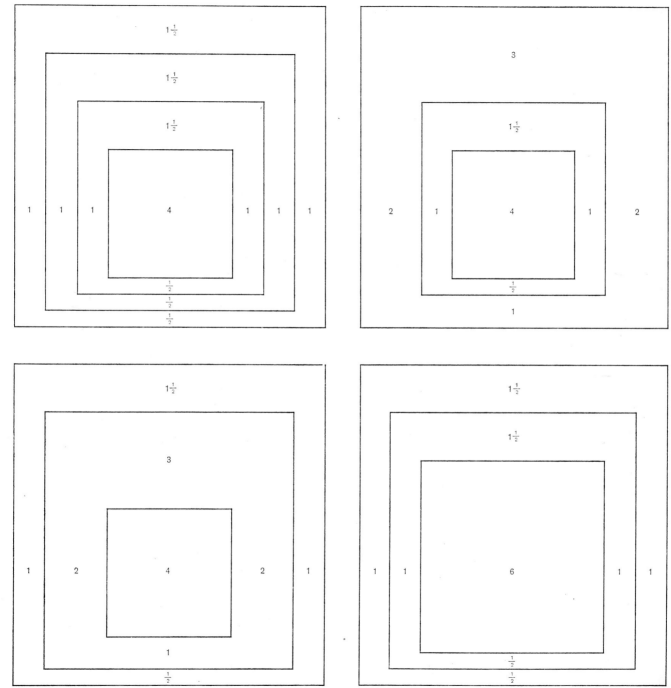

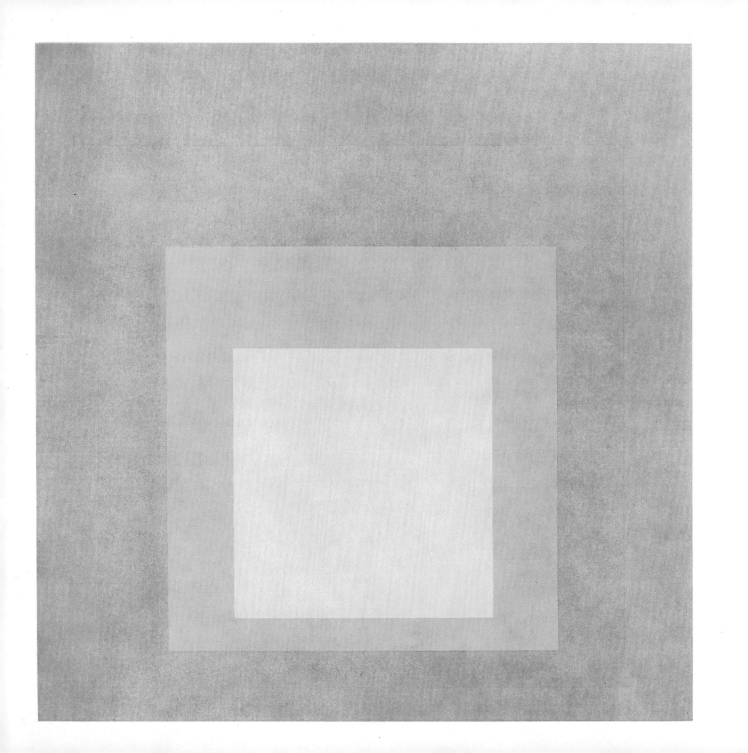

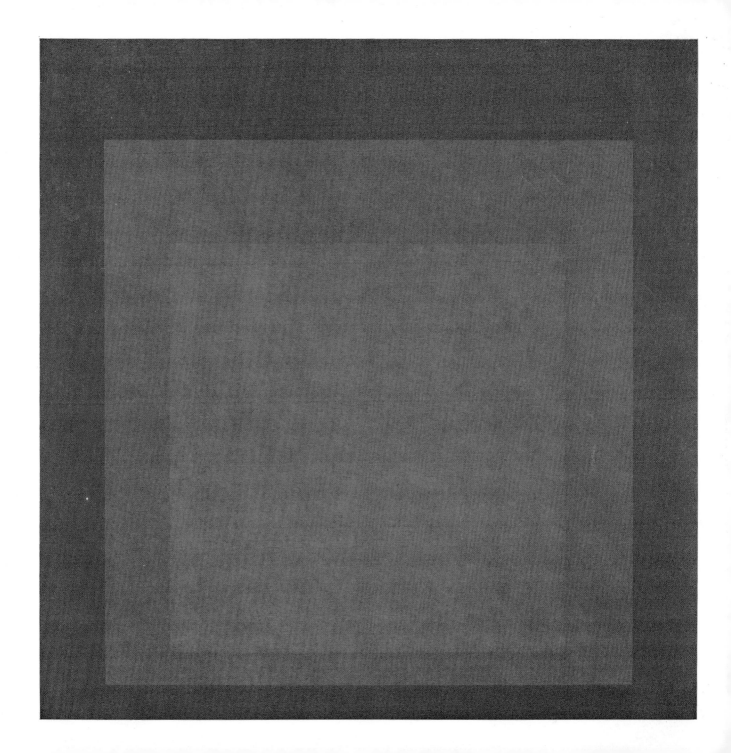

51

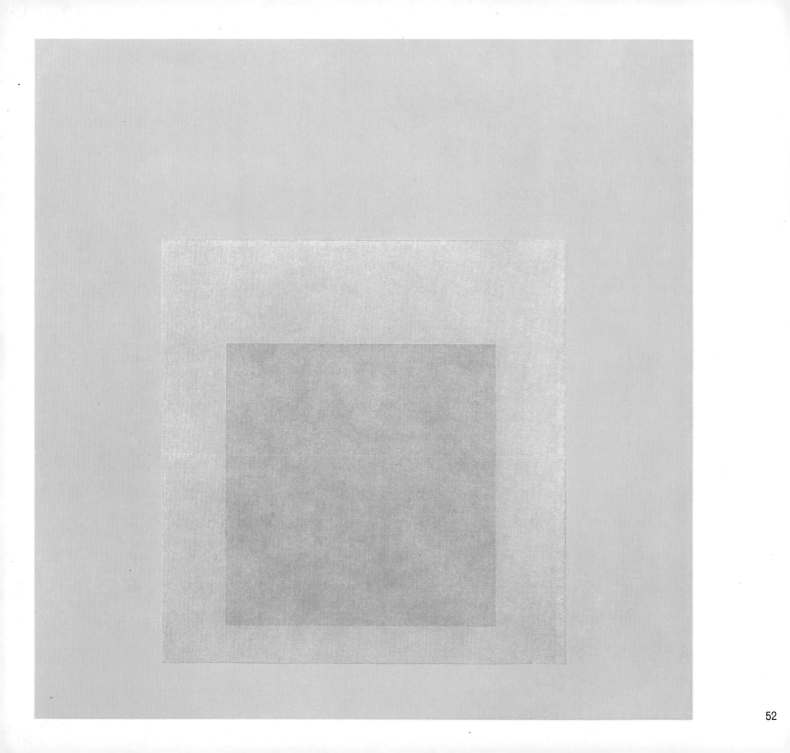

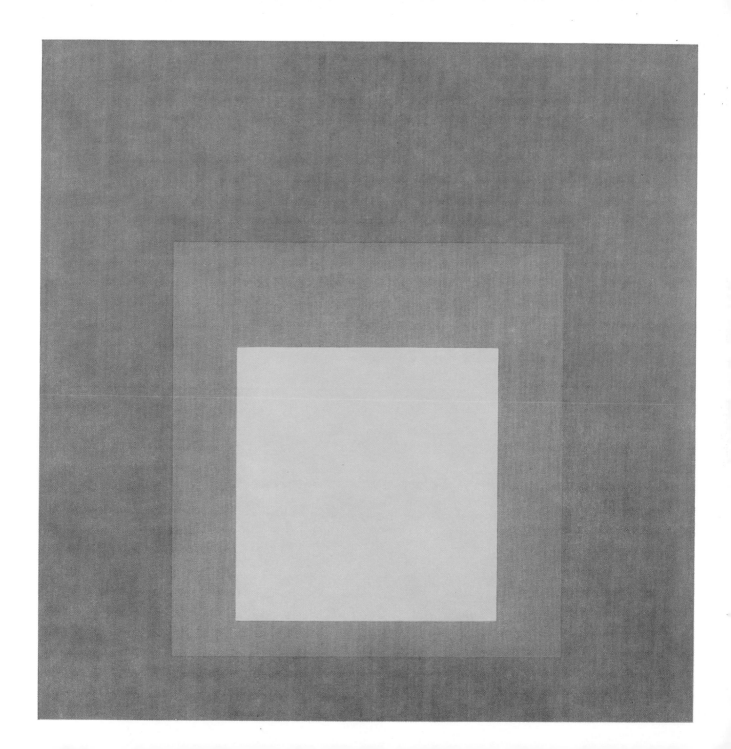

53

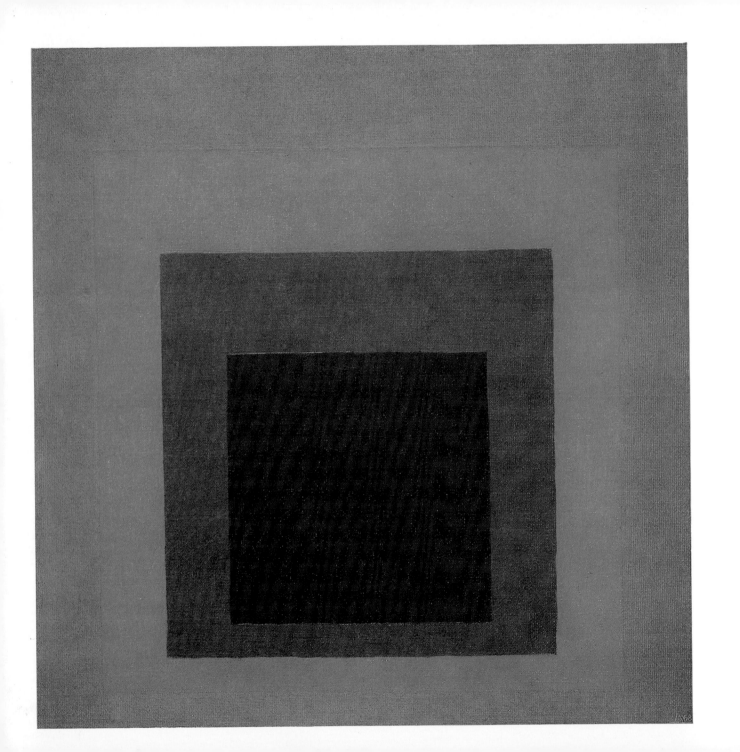

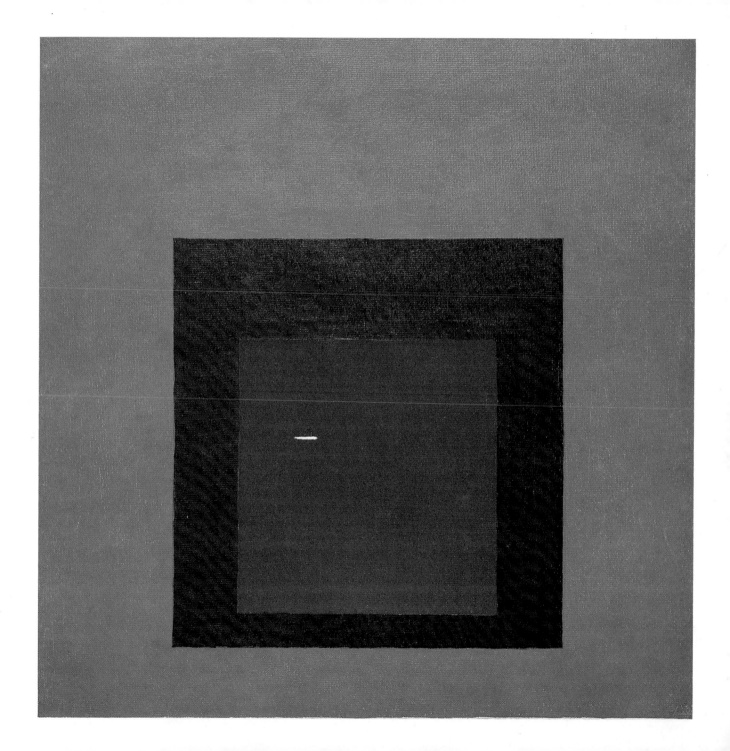

55

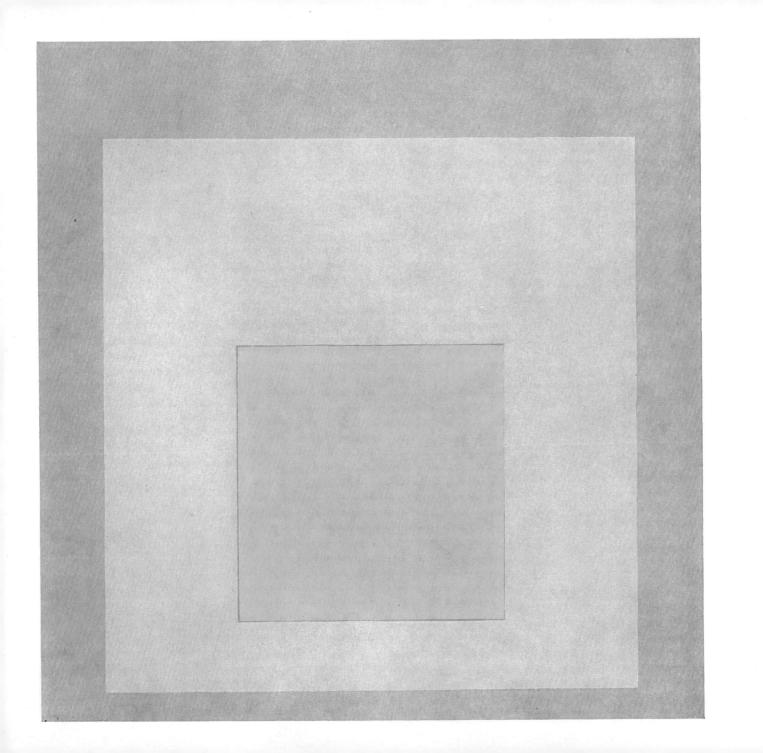

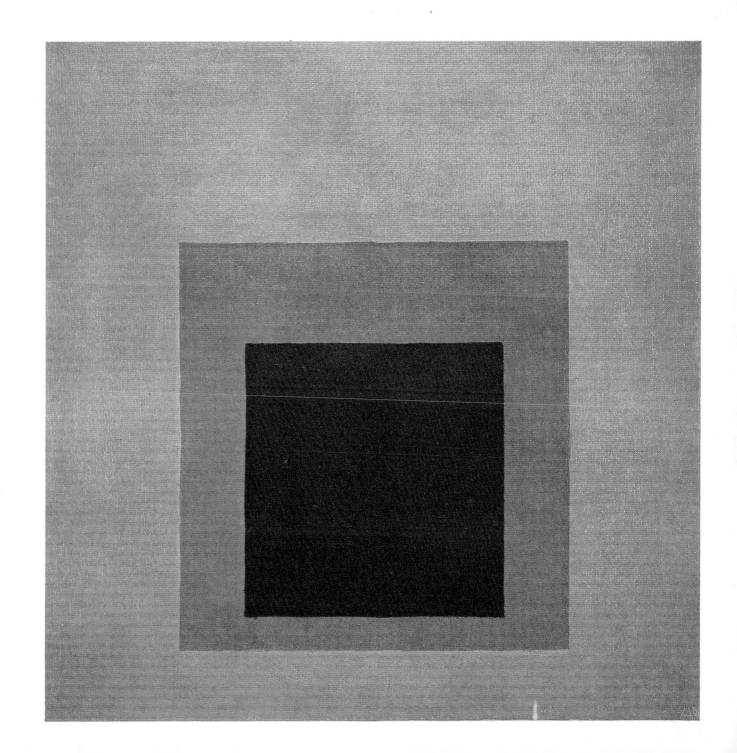

the horizontal symmetry is in sharp contrast to the vertical, asymmetric seriation. Thus zones are created of different chromatic activity.[18] In the ribbon-shaped small strips which lie in the lower half of the picture, the picture produces a more colorific effect than in the other more broadly planned zones. Everywhere, however, the important point is the alternating modification of colors. A color which lies between two others is influenced by them; the color of the panel on the right is being repeated along the border line on the left, and on the right border line it is the color of the panel on the left. Over and above the actually used colors, new optical mixtures are created.

Albers and Optical Art

In many respects Albers may be considered the precursor and stimulator of an art geared to optical effects. However, it would be unfair to judge Albers' work only in terms of optical art: the philosophical and social aspects of his work are usually missing in the works of the typical Op artist. Albers always admitted a certain relationship to Optical Art, but he repeatedly objected to the terminology used for the visual preoccupation thus designated. Albers strongly attacked this terminology in his article "Op Art and/or Perceptual Effect" (Op-Kunst und/oder Perzeptueller Effekt): "To call any sort of pictorial art 'optical art' makes just as little sense as to speak of acoustic music or of tactile sculpture." Before the concept of optical art had emerged, Albers had proposed to call his work "perceptual painting". This is what he meant: an art which is strictly oriented toward perception and which exploits the various shades of our capability to be stimulated. This is the decisive achievement of Albers: to confine himself to the non-literary wealth of that which we can see. The development of Albers, the artist and the teacher, his writings, his pronouncements are a guarantee for the fact that we are not dealing merely with a spectacle for the retina, but that over and above the variations of the act of seeing, he wanted to touch on human and social problems. One reason for Albers' strong rejection of the term "optical art" is his fear that the physical stimulus might be completely satisfied at the expense of the post-retinal, post-optical effect. Albers' work is based on the premise that an exchange of psychic-physical facts will be the result of close inspection of a picture.

Teaching and Work

Albers was a passionate teacher who created a work in which individual fulfillment and responsibility for all-embracing, moral and social aesthetics interlace; yet there were times when he wanted to be free of the ballast of his fame as a pedagogue.[19] We have become more sensitive to his doctrine. It belongs to his work, it accompanies it as a commentary and creates the intellectual climate for it. Albers never was an art teacher in the customary sense. He never forced his students to adopt a certain style. 58

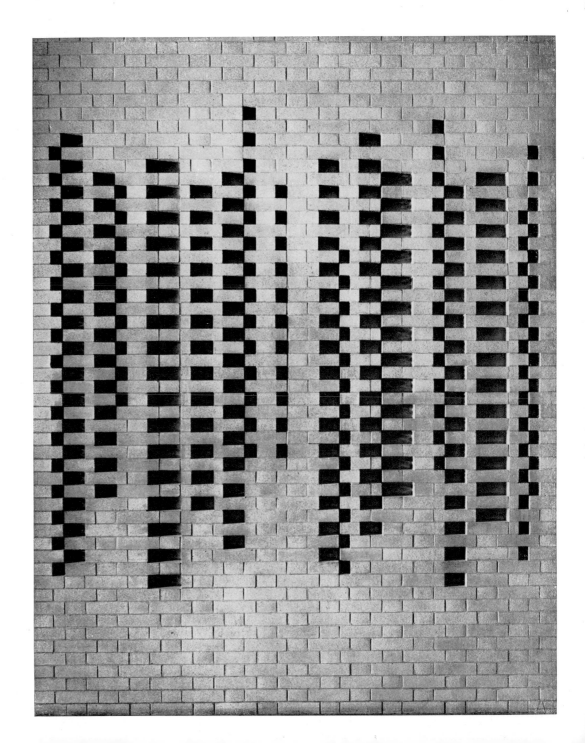

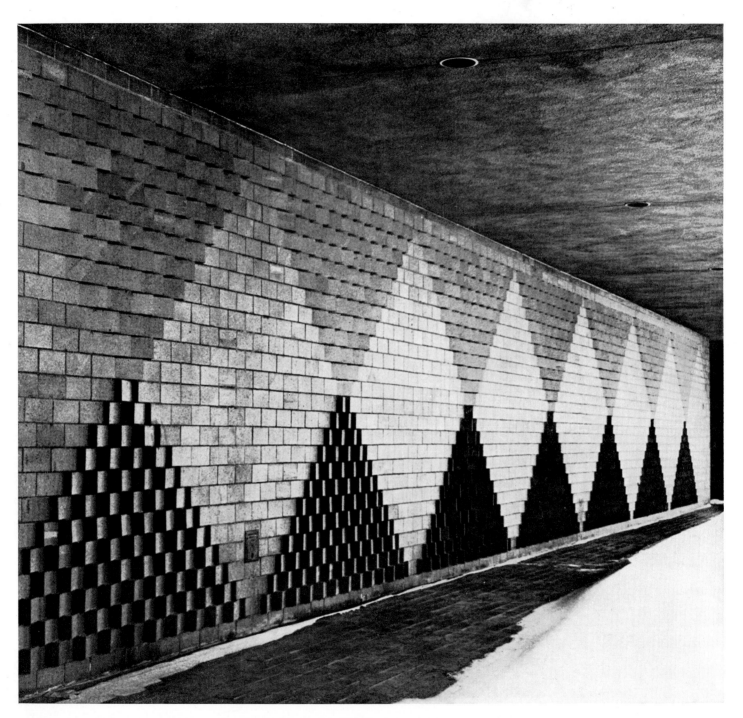

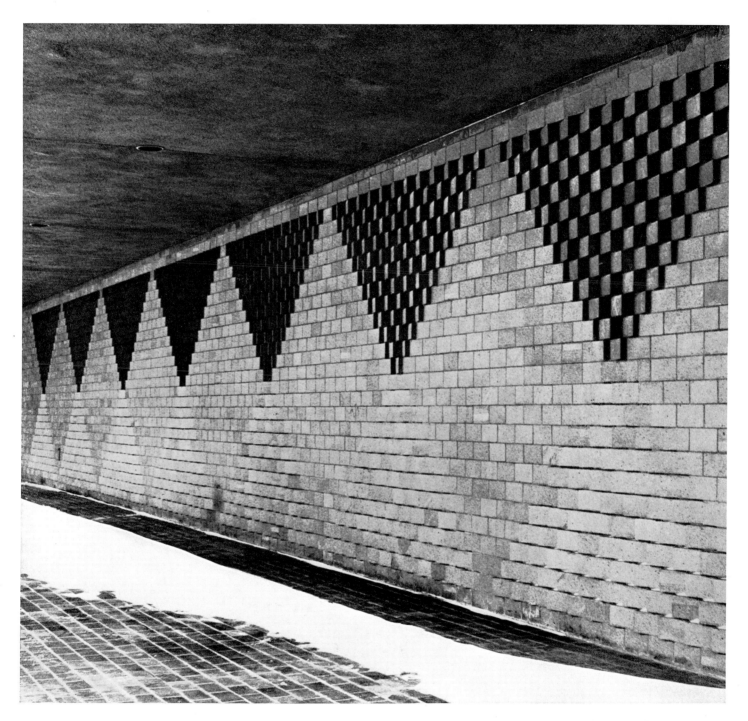

61

He did not teach painting, but seeing: not art, but the psychology and philosophy of art.[20] The accounts rendered by Albers of his work as a teacher are an expression of admirable humility, a humility which recognizes each and every individual and wants to help him to arrive at his own fulfillment.[21] And this was as it should be with a man who based his whole work on non-quantifiable elements, who always avoided any absolute result, and who, from the very beginning, replaced the exemplary individual work with work in series. There is of course a philosophy in this form of work: the individual work is reduced in value by the juxtaposition of equally important solutions (or approaches) differing often only in slight details. We have statements from Albers which confirm this interdependence of his works: "I have always worked in periods in which I concentrated on certain basic problems. I was surprised to see that these periods became ever longer. I think the reason for this is that in my experience each form demands manifold attempts and elaboration. I do not believe that there is one single solution for a formal expression of meaning. There is never anything really conclusive for me."[22]

Our encounter with Albers' work must to a considerable extent be based on comparisons. By continuous comparing one becomes even more conscious of the unstable, situation-bound status of the work. Work and teaching activity coincide in this point. Both demand a flexible preoccupation with art not conditioned by absolutism (the work as an absolute result—teaching activity as transmission of an absolute theory). This leads, via meditation, to demanding the most of oneself.

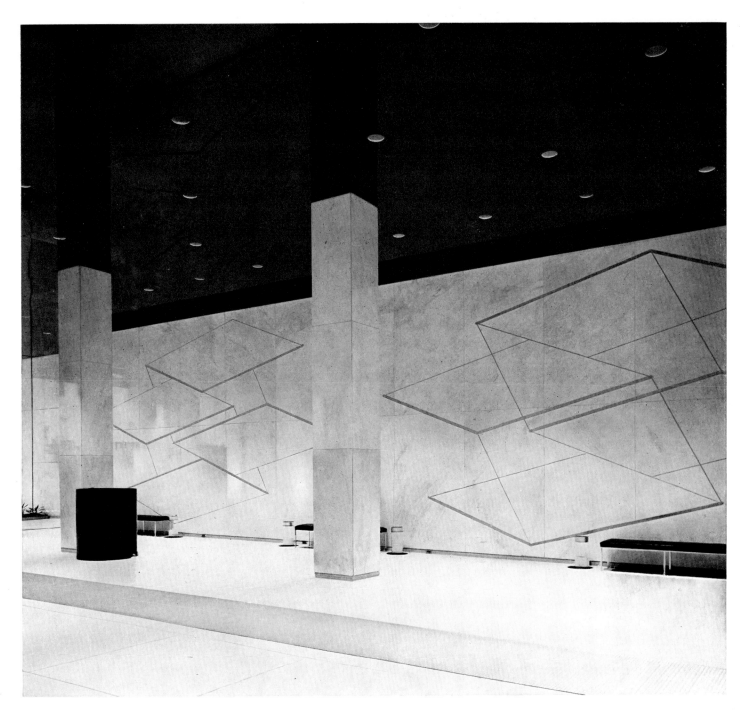

Notes

[1] In the preface to his catalogue William C. Seitz presents Albers and Vasarely as the "masters of perceptual abstraction".

[2] Text dated 31 May 1959.

[3] "Concerning Art Instruction," *Black Mountain College Bulletin*, No. 2, 1934.

[4] Katherine Kuh, *The Artist's Voice. Talks with seventeen artists*. New York and Evanston, Harper & Row Publishers, 1962, page 11.

[5] Max Imdahl described the historical preconditions of thematisized seeing in creative art; cf. "Probleme der Optical Art: Delaunay-Mondrian-Vasarely" in the Wallraf-Richartz Yearbook, Vol. XXIX, 1967, pages 291—308.

[6] Albers reports on this in a text which appeared in 1961 in the catalogue of the Albers Exhibition of the Stedelijk Museum in Amsterdam. Reprinted in part in Eugen Gomringer: *Josef Albers*. Starnberg, Josef Keller Verlag, 1968.

[7] The important thing is this: Albers prefers the arranging of fragments and odd forms to painting and composing. In *Interaction of Color* he points out the advantages of the experimental method of working, which, instead of relying on brush and color, reverts to a palette of color papers found at random: "Sources easily accessible for many kinds of color paper are waste strips found at printers and bookbinders; collections of samples of packing papers, of wrapping and bag papers, of cover and decoration papers. Also, instead of full sheets of paper, just cutouts from magazines, from advertisements and illustrations, from posters, wallpapers, paint samples, and from catalogues with color reproductions of various materials will do. Often a collective search for papers and a subsequent exchange of them among class members will provide a rich but inexpensive color paper "palette" . . . Color paper also protects us from the undesired and unnecessary addition of socalled texture (such as brush marks and strokes, incalculable changes from wet to dry, or heavy and loose covering, hard and soft boundaries, etc.) which too often only hides poor color conception or application, or, worse, an insensitive color handling." *(Interaction of Color*, ch. III. This extremely interesting paragraph is quite typical of Albers' working methods. Albers does not mix colors—instead he uses readymade color mixtures. He uses them—just as he uses the color papers—as finished elements. He describes the colors used on the back of the picture; for example—Color tone and originator of the color used—Mars Violet (Lefebre), Mars Violet (Bocour), Ferrous Violet deep (Shiva), Paynes Gray (Shiva Signature).

[8] *Interaction of Color*, ch. XXV.

[9] Albers proceeds here from a seriation, a principle of ground elements which he himself called "thermometer style". He did such formations of series also with objects, such as coffee-house chairs out of which he made compositions.

[10] Marcel Breuer calls Albers a frustrated architect.

[11] Jan Leering discussed this problem in the catalogue he wrote for the Van Doesburg Exhibition

at the Stedelijk van Abbemuseum in Eindhoven in 1968. He dwells particularly on the relationship between Gropius and Van Doesburg.

[12] In this connection Lux Feininger, the son of Lyonel Feininger, writes: "The basic conception was so decisively changed by Albers that only the name remains." "The Bauhaus-Evolution of an Idea", in *Criticism—a Quarterly for Literature and the Arts*, Vol. II, No. 3, 1960.

[13] "Reihungen" (Sequences) as opposed to "Häufungen" (Accumulations, or literally Heapings), a new design concept at the time.

[14] Max Imdahl says about the *Structural Constellations*: "Our certainty about space ends up in utter uncertainty because of a completely definite area syntax, a broadening of perception through the paradox." In *Josef Albers: graphic tectonic*, published by Margit Staber. Cologne, Gallery Der Spiegel, 1968.

[15] Albers describes the procedure which M. E. Chevreul (1786—1889) used in *Interaction of Color*, ch. XX: "Upon a sheet of cardboard divided into ten stripes, each about a quarter of an inch broad, lay a uniform tint of India ink. As soon as it is dry, lay a second tint on all the stripes except the first. As soon as the second is dry, lay a third one on all the stripes except the first and second, and so on all the rest, so as to have ten flat tints gradually increasing in depth from the first to the last."—Albers continues: "All this sounds quite convincing, so convincing that one wonders whether anyone has ever doubted that the result would be as promised— whether anyone has ever followed these instructions, including M. Chevreul himself."

[16] It is important to relate Albers' works to theory. In a letter dated 18 October 1969 he writes to the author: "I very consciously want my work to be an invitation to follow my creation—i. e. to follow my procedure. I want it to become clear that the creative process identifies its two criteria: discovery and invention. Thus we arrive at a new blissful and secure understanding of life; to see 'art' is a wonderful affirmation of life."

[17] "Although quantity and quality often are considered disparate, in art and music they appear closely related. We may even hear 'quantity is a quality', because here quantity not only designates amounts, as of weight or number, but also is a means of underlining, of pronouncement, and a means of equilibrium, of balance. One who particularly recognized the latter was Schopenhauer. When he tried to improve Goethe's 6-part color circle—to Goethe's dismay— he changed the previous presentation of 6 equal areas to decidedly different quantities. Thus yellow, the lightest color, appears in the smaller amount, and its opposite, violet, as the darkest, in the largest amount." (*Interaction of Color*, ch. XVI.)

[18] "Such considerations are both the source and result of our quantity studies, in which 4 colors usually appear in 4 different juxtapositions, so different that all 4 studies appear as unrelated as possible. And thus they present changes in climate or temperature, in tempo or rhythm— that is, changes of atmosphere or mood, so that the factual contents (the same 4 colors) are hidden or, better, hardly recognizable." (*Interaction of Color*, ch. XVI.)

[19] The first important publication dedicated to Albers, Eugen Gomringer's monograph, almost completely passes over Albers as a teacher. This did not happen by chance. It was based on a decision to give full recognition to Albers the artist. Only a strict separation between his actual artistic work and his pedagogic work (which in the artistic world has never been fully recognized) seemed to make this possible. The situation has somewhat changed in the meantime. The artistic work of Albers has become world-famous. Besides the deep experience transmitted by the *Homage to the Square*, there now exists the knowledge of the various stages of his work.

[20] "Although I have now taught art for almost forty years, I have finally realized that I did not teach art, but psychology, and the philosophy of—structure. I did not teach painting, but seeing, and not design, but structural organization. I did not show how to do what, to recognize what that which one does means—to others." (Letter of 18 October 1969 addressed to the author.)

[21] "I do not wish to make the definite assertion that actual artistic practice cannot be taught, or learned. But we do know with certainty that openmindedness and understanding of art can be developed by learning (i. e. through the cultivation of intuitive ability to perceive and to differentiate), and by teaching (the conveying of proven knowledge). Just as each human being is equipped with all physiological senses (in different proportional and qualitative degrees), so— in my opinion—each is equipped with a complete psychological perceptiveness, such as the feeling for sound, color or space. Here, perhaps, the degrees may be considerably more divergent." ("Concerning Art Instruction," *Black Mountain College Bulletin*, No. 2, 1934.)

[22] *The Artist's Voice*, see note 4.

40 Schematic Transformation No. 9, 1949. Engraving on plastic, white on black, 19″ × 25¹/₂″

41 Schematic Transformation No. 8, 1949. Engraving on plastic, white on black, 19″ × 25¹/₂″

42 Four Structural Constellations. Drawing, black on white, 16″ × 17″

43 Four Structural Constellations. Drawing, black on white, 16″ × 17″

46 Variations on a Theme II, 1967. Screen-printing

47 Variations on a Theme VIII, 1967. Screen-printing

49 Schema for the Square series

50–57 Eight pictures from the Homage to the Square series

59 America, 1949–50. Brick wall, Harvard University. Wall measurements: c. 10′10″ × 8′6¹/₂″; mural measurements c. 7′6″ × 7′11″

60 Outside wall in the courtyard of the scientific laboratory of the Rochester Institute of Technology, Rochester, N. Y., 1967. View toward exit

61 Outside wall in the courtyard of the scientific laboratory of the Rochester Institute of Technology, Rochester, N. Y., 1967. View toward entrance

63 Structural Constellations, 1959. Carved in marble and goldplated, c. 13′ × 58′6″. Corning Glass Building, New York City

Biography

1888	Born on March 19 in Bottrop, Westphalia
1902—05	Secondary School at Langenhorst near Rheine
1905—08	Teacher Seminary at Bueren, Westphalia
1908—13	Elementary school teacher in Bottrop, Weddern and Stadtlohn
1908	First art trip to Munich. Visit to the Folkwang Museum in Hagen. First acquaintance with the works of Cézanne and Matisse. Meets Osthaus and Christian Rohlfs
1913—15	Royal Art School, Berlin
1913	First abstract picture
1916—19	Continues as elementary school teacher in Bottrop, and attends School of Applied Arts in Essen; first lithographs, woodcuts and linocuts
1919—20	Student in painting class of Franz Stuck at the Art Academy, Munich; attends a course in painting technique given by Max Doerner
1920—23	At Bauhaus in Weimar; after the preliminary course independent work with glass pictures
1922	As an apprentice, organizes the reopened glass workshop
1923	Is appointed to teach crafts
1925	Moves to Dessau with the Bauhaus. Is appointed "Bauhaus Master". Marries Anni Fleischmann. Trips to Italy
1926	Further development of glass wall pictures. Illustrations in typography, making articles for daily use out of glass and metal. Designing of furniture
1928	After the departure of Gropius, Albers remains at the Bauhaus. Gives a lecture on creative education at the International Congress for Art Education in Prague
1928—30	After the departure of Breuer is put in charge of the furniture workshop
1929	Contributes twenty glass pictures to the Exhibition of Bauhaus Masters in the Kunsthalle, Basle, and in the Kunstgewerbemuseum in Zurich
1930	Continues his teaching activity at the Bauhaus under Mies van der Rohe
1932	Because of political repression the Bauhaus is transferred to Berlin; Albers continues as head of the preliminary course
1933	The Bauhaus is closed. Josef and Anni Albers receive a call to teach at the newly founded Black Mountain College in North Carolina, U.S.A.
1934	First series of lectures at the Lyceum Habana, Cuba
1935	First trip to Mexico

1936—40	Lectures at the Graduate School of Design, Harvard University
1936—41	More than twenty one-man exhibitions of glass pictures of the Bauhaus period, and of paintings, in American galleries
1941	Teaches a course in elementary form and color at Harvard University
1948—50	Consultant to the Art Committee at Yale University
1949	Josef and Anni Albers leave Black Mountain College. Trips to Mexico; Visiting Professor at the Art Academy in Cincinnati. Courses in color and at the workshop of the Pratt Institute in Brooklyn, New York
1950	Visiting Professor at the Graduate School of Design, Harvard University; Director of the Department of Design at Yale University. Mural *America* for the Harvard Graduate Center
1953—54	Visiting Professor at the Universidad Catolica, Santiago, Chile. Lectures at the Institute for Technology, Lima, Peru; Visiting Professor at the Hochschule für Gestaltung in Ulm
1955	Visiting Professor at the Hochschule für Gestaltung, Ulm
1957	Receives the Cross of Merit First Class of the Order of Merit of the Federal Republic of Germany; Doctor of Fine Arts, *honoris causa*, University of Hartford, Connecticut
1957—58	Visiting Professor at the Carnegie Institute, Pittsburgh
1958	Receives the Konrad von Soest Prize of the Landscape Association *(Landschaftsverband)*, Westfalen-Lippe
1958—59	Visiting Professor at Syracuse University, Syracuse, New York
1959	Director of the Department of Design, Yale University; Visiting Professor at the University of Minnesota, at the Kansas City Art Institute, and at the Art Institute of Chicago. Design of the mural *Structural Constellations* for the Corning Glass Building in New York Fellowship and grant of the Ford Foundation, New York
1960	Visiting Professor at Yale University Art School, at Princeton University, and at the Chicago Art Institute. Design of the mural *Two Gates* for the Time-Life Building in New York. Trip to Europe
1962	Visiting Professor at the University of Oregon Fellowship and grant of the Graham Foundation, Chicago; Citation of the Philadelphia Museum College of Art; Doctor of Fine Arts, *honoris causa*, at Yale University

1963	Design of the mural *The City* for the Pan-American World Airways Building, New York
1964	Series of lectures at Smith College, Northampton, and at the University of Miami. Steel sculpture *Repeat and Reverse* for the Art and Architecture Building of Yale University; Medal of the Year 1964 of the American Institute of Graphic Art, New York; Doctor of Fine Arts *h. c.* at the California College of Arts and Crafts, Oakland, California
1965	Series of lectures at Trinity College, Hartford, Connecticut
1966	Visiting Professor at the University of South Florida, Tampa, and at Bridgeport University; Doctor of Laws *h. c.* at the University of Bridgeport, Connecticut
1967	Doctor of Fine Arts *h. c.* at the University of North Carolina, Chapel Hill; Carnegie Institute Award for Painting, Pittsburgh. International Exhibition; Dr. phil. *h. c.* at the Ruhr University in Bochum, Germany
1968	Grand Prix of the Third Bienal Americana Grabada, Santiago, Chile; Distinguished Service Cross of the Order of Merit of the Federal Republic of Germany
1969	Doctor of Fine Arts *h. c.* of the University of Illinois, Urbana, and of the Minneapolis School of Art, and of Kenyon College, Gambier, Ohio
1970	Benjamin Franklin Fellowship of the Royal Society of Arts in London

Principal One-Man Exhibitions

1936 Newspaper *El National*, Mexico City
1936 New Art Circle, New York
1938 New Art Circle, New York
 Artists Gallery, New York
1940 San Francisco Museum of Art, San Francisco
1942 Baltimore Museum of Art, Baltimore, Maryland
1944 Mint Museum of Art, Charlotte, North Carolina
1945 New Art Circle, New York
1946 Egan Gallery, New York
1947 California Palace of the Legion of Honor, San Francisco
1949 Egan Gallery, New York
 Sidney Janis Gallery, New York
 Cincinnati Art Museum, Cincinnati, Ohio
 Museum of Fine Arts, Richmond, Virginia
 Yale University Art Gallery, New Haven, Connecticut
1950 J. B. Speed, Art Museum, Louisville, Kentucky
1951 Contemporary Art Society, Sydney, Australia
1952 Sidney Janis Gallery, New York
1953 San Francisco Museum of Art, San Francisco
 Wadsworth Atheneum, Hartford, Connecticut
1954 Academy of Art, Honolulu, Hawaii
1955 Sidney Janis Gallery, New York
 Massachusetts Institute of Technology, Cambridge, Massachusetts
1956 Kunsthaus Zurich
1957 Museum der Stadt Ulm, Ulm
 Karl-Ernst-Osthaus-Museum, Hagen
1958 Sidney Janis Gallery, New York
 Landesmuseum Münster/Westfalen
 Kunstverein Freiburg i. Br.
1959 Sidney Janis Gallery, New York
 Landesmuseum Münster/Westfalen
1961 Gimpel Fils, London
 Sidney Janis Gallery, New York
 Stedelijk Museum, Amsterdam

1962	Mint Museum of Art, Charlotte, North Carolina
1963	Sidney Janis Gallery, New York
	Gallery Hybler, Copenhagen
1963	Kunsthaus Hamburg
	Museum Folkwang, Essen
	Dallas Museum of Fine Arts, Dallas, Texas
	San Francisco Museum of Art, San Francisco
1964	Sidney Janis Gallery, New York
	Wilhelm-Morgner-Haus, Soest/Westfalen
	Trinity College, Hartford, Connecticut
1965	Galleria Toninelli, Milan
	Gimpel & Hanover, Zurich
1965/1966	Travelling exhibition of the Museum of Modern Art, through ten most important museums of South America, and two museums of Mexico City
1966/67	The same travelling exhibition in eight different museums of the U.S.A.
1968	Galerie Denise René, Paris
	Landesmuseum Münster/Westfalen
	Kestner-Gesellschaft, Hannover
1969	Many exhibitions in the U.S.A.
	Kunstverein Munich
	Kunsthalle Hamburg
1970	Retrospective at the Städtische Kunsthalle Düsseldorf

Bibliography

Publications by Josef Albers

1924

"Historisch oder jetzig," in *Junge Menschen—ein Monatsheft* (Hamburg), Special number of *Bauhaus*, vol. 5, no. 8, November, p. 171.

1928

"Werklicher Formunterricht," *Bauhaus* (Dessau), no. 2/3.

1931

Kombinationsschrift "3," *Bauhaus* (Dessau), no. 1.

1934

"Concerning Art Instruction," *Black Mountain College Bulletin* (North Carolina), no. 2, June, pp. 2—7.

1936

"Note on the Arts in Education," *American Magazine of Art*, no. 29, April.

1944

"The Educational Value of Manual Work and Handicraft in Relation to Architecture," in Paul Zucker, *New Architecture and City Planning*. New York, Philosophical Library, pp. 688—694.

1946

"Present and/or Past," *Design* (Columbus, Ohio), no. 47, April, pp. 16—17.

1958

Poems and Drawings. New Haven, Readymade Press; 2nd revised edition 1961, New York, Wittenborn.

1961

Despite Straight Lines. An analysis of graphic constructions by François Bucher with an explaining text by Josef Albers. New Haven and London, Yale University Press.

1962

Homage to the Square. 10 screen prints. New Haven, Ives-Sillman.

1963

Interaction of Color. New Haven and London, Yale University Press.

1965

"Op Art and/or Perceptual Effects," *Yale Scientific Magazine*, November.
Homage to the Square, Soft Edge—Hard Edge. 10 screen prints with text by Josef Albers. New Haven, Ives-Sillman.

1967

Variants. 10 screen prints, introduction by Josef Albers. New Haven, Ives-Sillman.
"My Courses at the Hochschule für Gestaltung at Ulm," *Form* (Brighton Festival Exhibition of Concrete Poetry), no. 4.

1969

Search Versus Re-Search. Hartford, Connecticut, Trinity College Press.

Publications about Josef Albers

1929—1930

Arthur Korn, *Glas im Bau und als Gebrauchsgegenstand*. Berlin-Charlottenburg, Ernst Pollak Verlag.

1938

L. Sandusky, "The Bauhaus Tradition and the New Typography," *PM* (New York), vol. 4, no. 7, June/July, 1938, pp. 1—34.

1948

Hans Hildebrandt, Exhibition catalogue *Josef Albers, Hans Arp, Max Bill*. Stuttgart, Galerie Herbert Herrmann.

1950

Ludwig Grote, Exhibition catalogue *Die Maler am Bauhaus*. München, Haus der Kunst.
Elain de Kooning, "Albers paints a picture," *Art News* (New York), November.

1954

Erhard Göpel, "Der Bauhaus-Meister Josef Albers," *Süddeutsche Zeitung*, no. 12, January 16/17.

1956

Max Bill, Exhibition catalogue *Josef Albers, Fritz Glarner, Friedrich Vordemberge-Gildenwart*. Kunsthaus Zürich.
George Heard Hamilton, *Josef Albers*. *Paintings*, *Prints*, *Projects*. New Haven, Yale University Art Gallery.

1957

Jean Arp, Will Grohmann, Franz Roh, *Josef Albers*. Paris, Galerie Denise René.

1958

Will Grohmann, "Zum 70. Geburtstag von Josef Albers," *Frankfurter Allgemeine Zeitung*, March 19.
Max Bill, "Josef Albers," *Werk* (Winterthur), vol. 4, April.
Eugen Gomringer, Catalogue of Kunstverein, Freiburg i. Br.
Eugen Gomringer, "Die Glasbilder von Josef Albers," *Die Glaswelt*, no. 17, November.

1960

T. Lux Feininger, "The Bauhaus: Evolution of an Idea," *Criticism*, vol. II, no. 3.

1961

Will Grohmann, "Josef Albers," *Museum Journaal* (Amsterdam), no. 9/10, April/May.

1962

Hans M. Wingler, *Das Bauhaus 1919—1933, Weimar, Dessau, Berlin*. Cologne, DuMont Schauberg.
Katherine Kuh, *The Artist's Voice. Talks with seventeen artists*. New York and Evanston, Harper & Row Publishers.

1965

Karl Gerstner, "Über Josef Albers' Interaction of Color," *Form* (Opladen), no. 29.
Margit Staber, "Farbe und Linie, Kunst und Erziehung. Zum Werk von Josef Albers," *Neue Graphik* (Zürich), no. 17/18.
Eberhard E. Roters, "Maler am Bauhaus," *Die Kunst unserer Zeit* (Berlin), vol. 18.
Gerald Nordland, *Josef Albers. The American Years*. Washington Gallery of Modern Art.

1967

Irving Finkelstein, "Albers' Graphic Tectonics, from a doctoral dissertation 'The Life and Art of Josef Albers'," Form (Brighton Festival Exhibition of Concrete Poetry), no. 4.

1968

Werner Spies, "Das Auge am Tatort. Josef Albers—Ein Porträt zum 80. Geburtstag," *Frankfurter Allgemeine Zeitung*, March 19.

Max Imdahl, "Constellations structurales de Josef Albers" in exhibition catalogue of the Gallery Denise René, Paris.

Eugen Gomringer, *Josef Albers. Das Werk des Malers und Bauhausmeisters als Beitrag zur visuellen Gestaltung im 20. Jahrhundert*. With articles by Clara Diament de Sujo, Will Grohmann, Norbert Lynton, and Michel Seuphor. Starnberg, Josef Keller Verlag.

Exhibition catalogue *Josef Albers*. With an introduction by Jürgen Wißmann. Landesmuseum Münster/Westfalen.

Exhibition catalogue *Josef Albers: graphic tectonic*. Edited by Margit Staber, with articles by Bernhard Andreae, Umbro Apollonio, Max Bill, R. Buchminster-Fuller, Karl Gerstner, Max Imdahl, Robert Le Ricolais, Dietrich Mahlow, Margit Staber. Cologne, Galerie Der Spiegel.

Werner Spies, "Op Art and Kinetic." Foreword in catalogue of Documenta IV, Kassel.

1970

Exhibition catalogue *Josef Albers*. Introduction by Werner Hofmann, articles by Kurt Alsleben, Dietrich Helms, Jürgen Wißmann, Josef Albers. Hamburg, Kunsthalle.

Exhibition catalogue *Josef Albers*. Foreword by Werner Spies, articles by Max Imdahl, Eugen Gomringer, Jürgen Wißmann. Düsseldorf, Städtische Kunsthalle.

Photographers Credit